SSP Digest
Special Edition

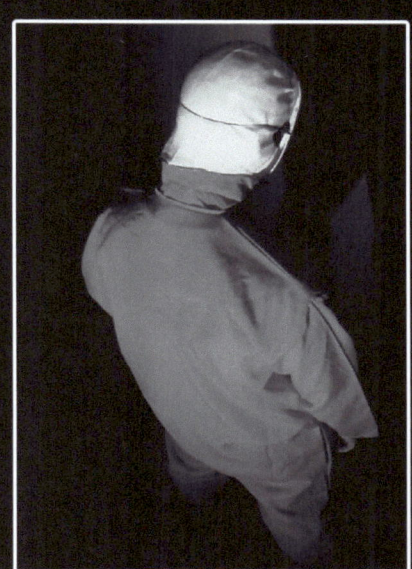
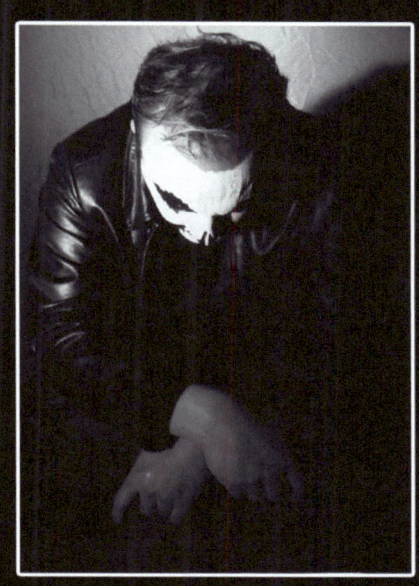
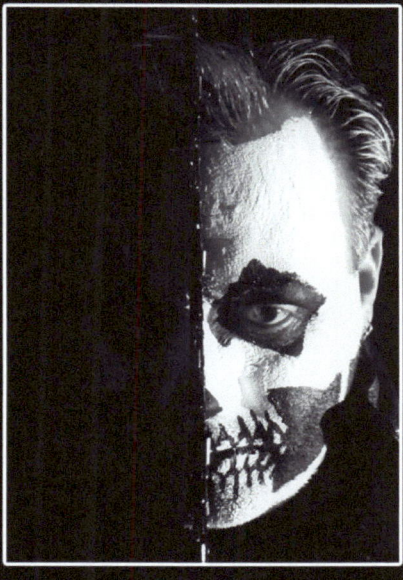

Cosplay Station

A World In Black & White

Copyright 2013 by Sound Impressions
SIP-007

All Rights Reserved. No part of this publication may be reproduced or transmitted in any form or by any means, electronic or mechanical, including photocopy, recording, or and other information storage and retrieval system, without the written permission of the publisher.

For information about custom editions, special sales, signings, premium, and corporate purchases please contact
Sound Impressions (973) 263-0521

Publisher: Sound Impressions
 Attn: Publishing
 PO Box 754
 Boonton, NJ 07005

 http://www.soundimp.net

Editing & Layout: Jason R. Koba

Photography by: Jason R Koba

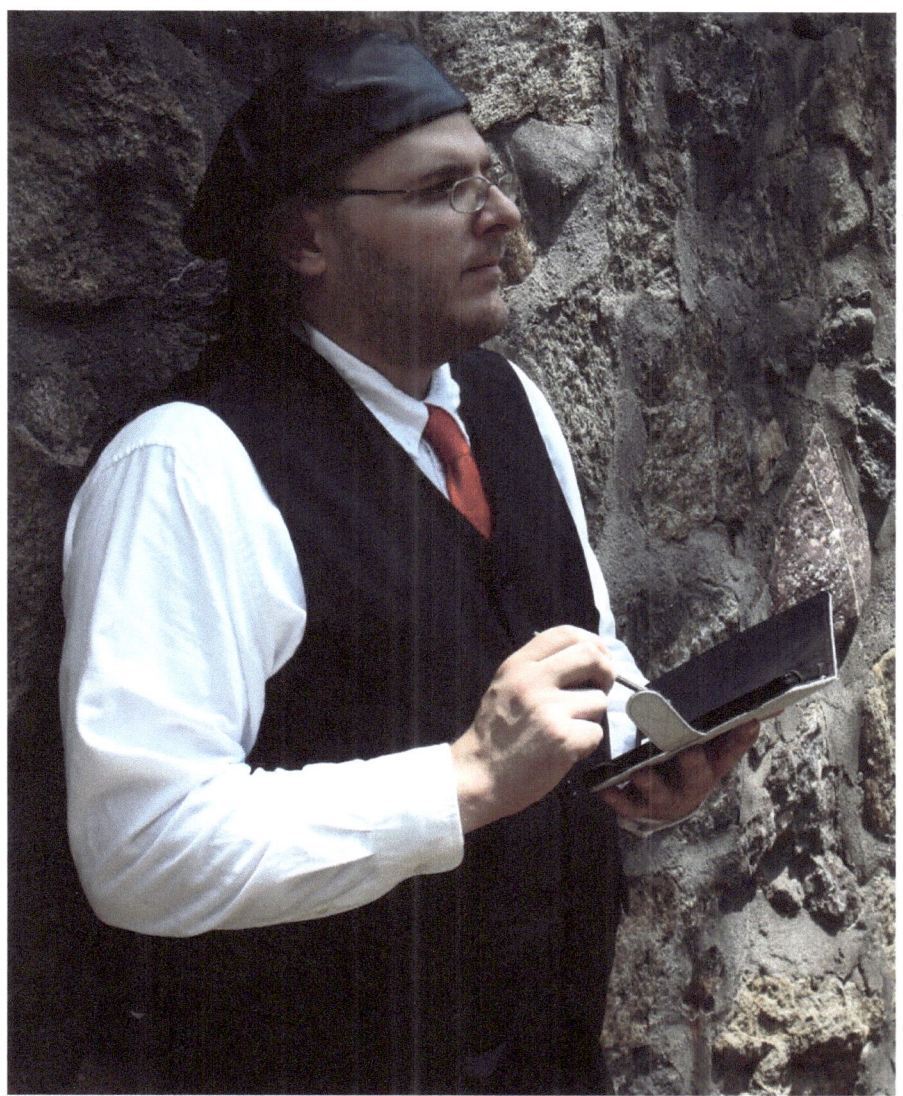

Professor K. aka Jason Koba has been working with mass media for over 20 years and over 1000 productions and projects, the professor has a long resume in the entertainment and art industry.

In 1996 he created StoryStick Productions which gave an outlet for his projects to build and grow into their own. Together with his fans, friends, and family he hopes to bring a new look to his visions of life and art.

Dedicated to my mother, who without her first steps into writing books I would never have taken this leap into showing my artwork to the world.

THE BLOODY SKELETON

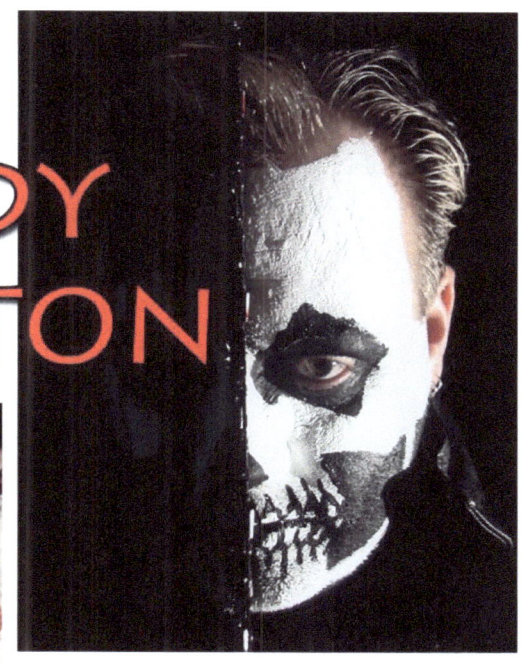

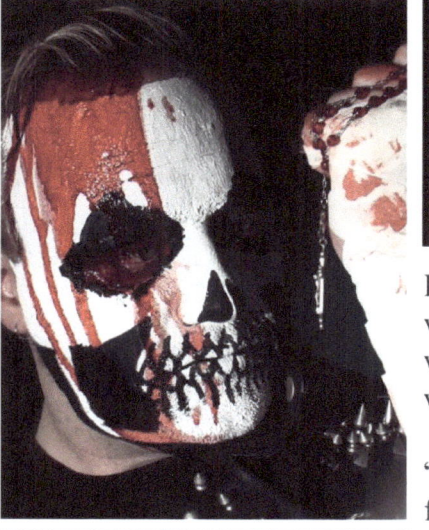

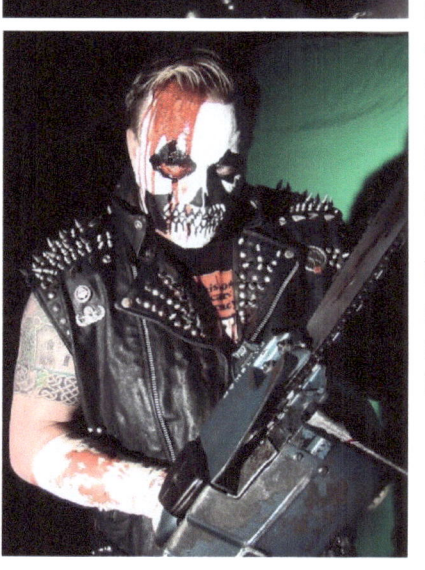

December 27, 2008 was the first shoot we had in the new studio location. And with a heating system that wouldn't work to its fullest potential.

"The Bloody Skeleton" was one of my favorites. As he was putting the character together in the freezing room, we created a lot of great shots. And to this day "Cosplay Station #1" is still being downloaded with the original published pictures in color.

Now, lets head down to "Shady Acres" and relive some of the original shots from the shoot in a black & white horror film idea like that of the 1950's.

Professor K

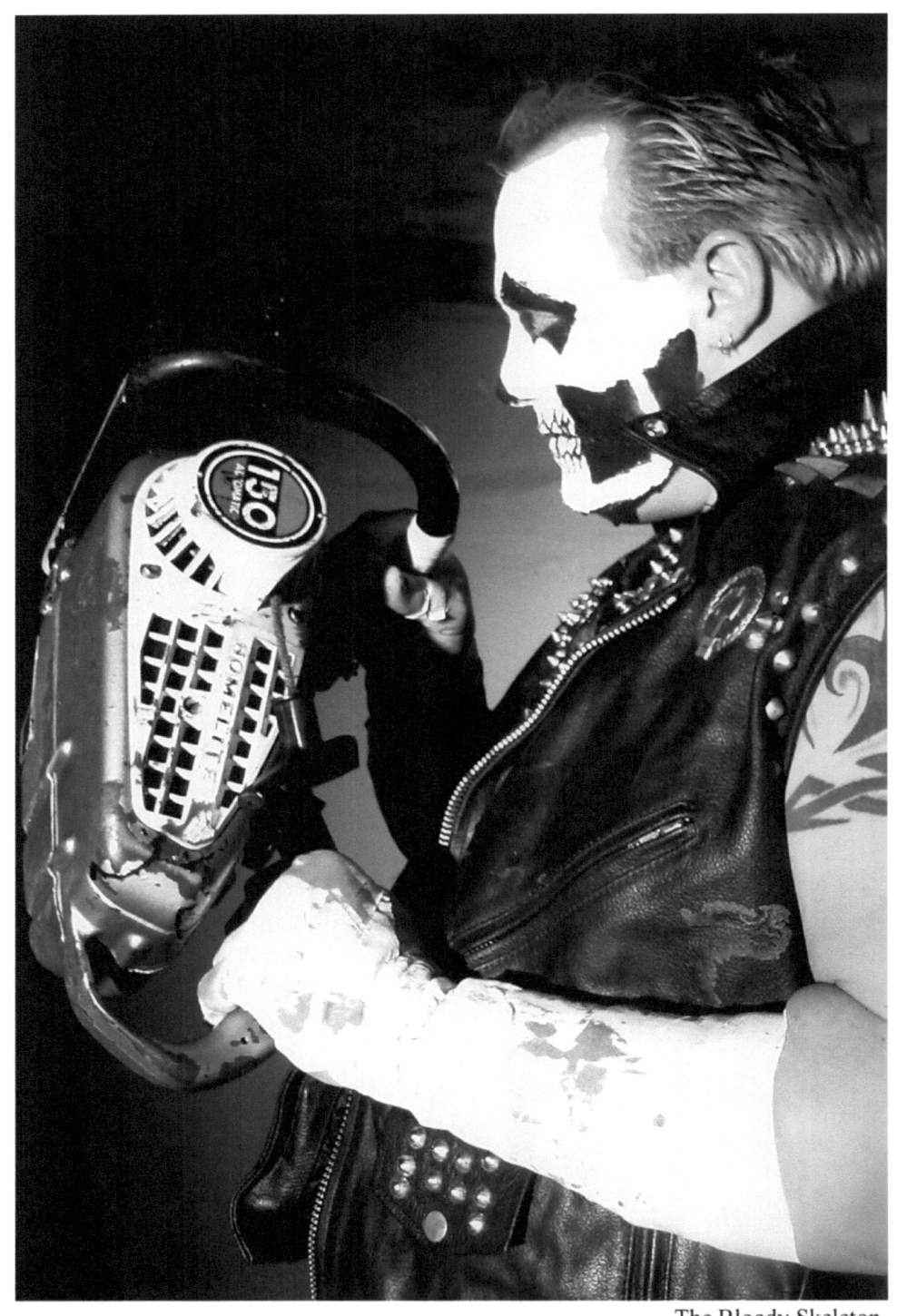

The Bloody Skeleton
Copyright 2008 - Jason Koba

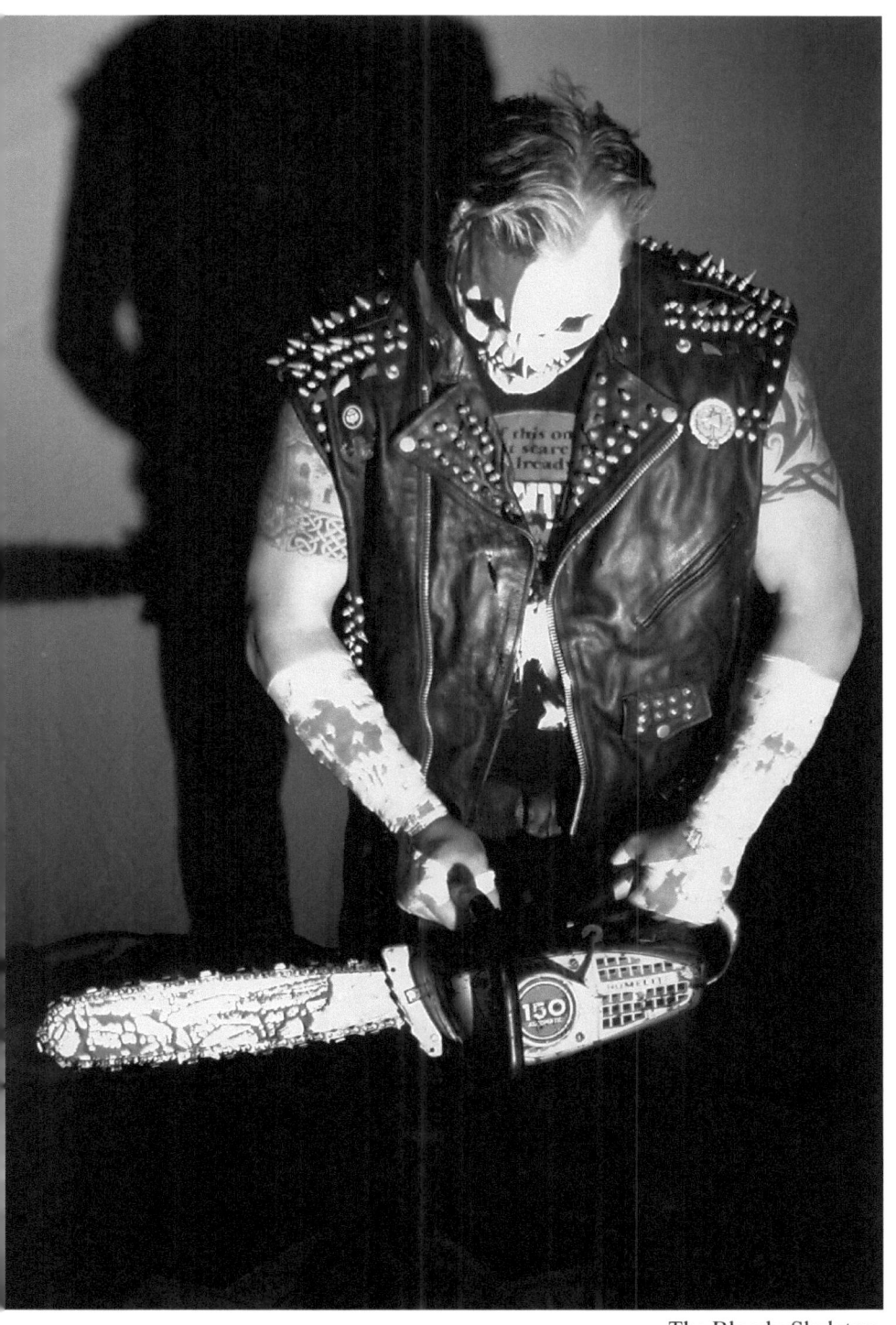

The Bloody Skeleton
Copyright 2008 - Jason Koba

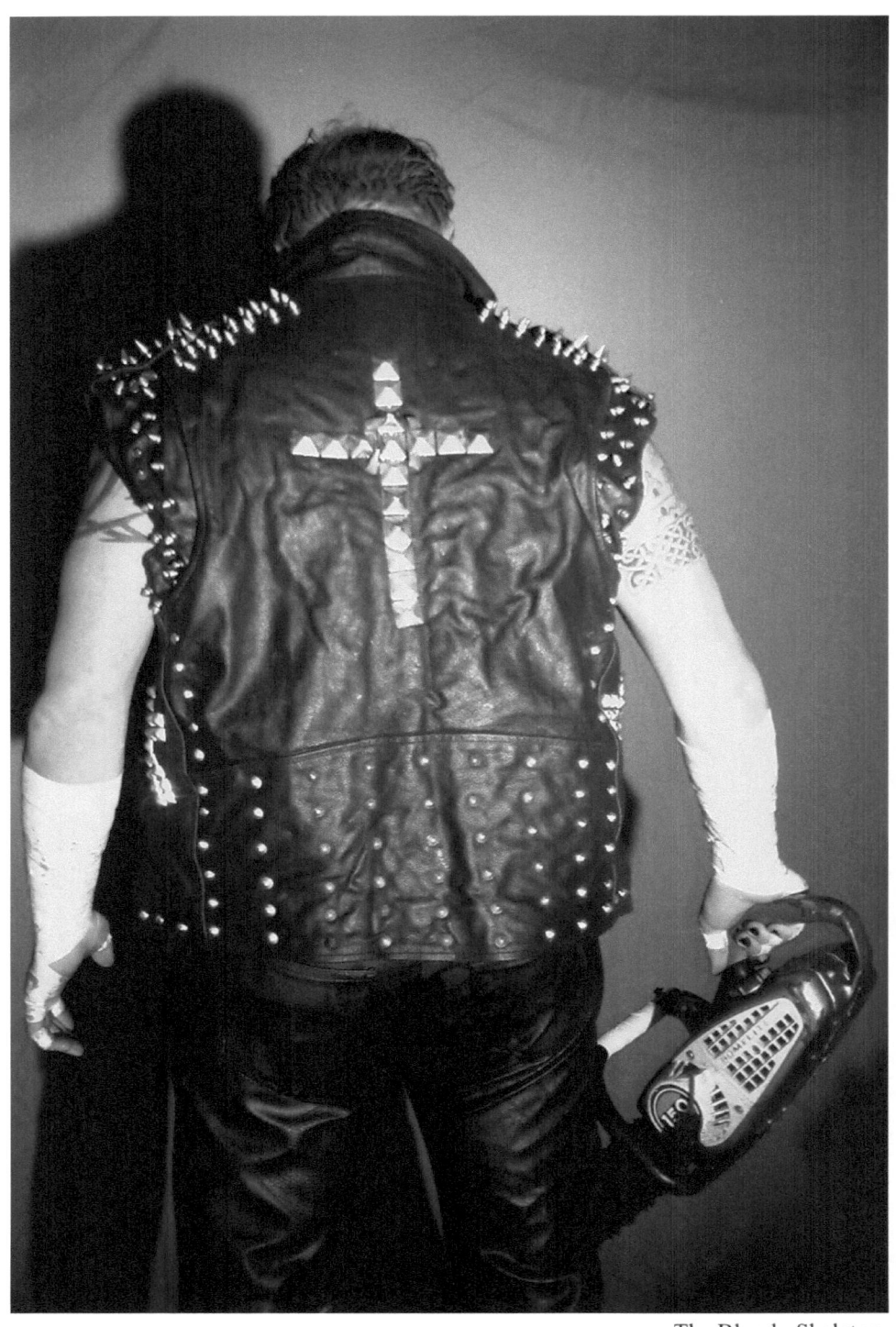

The Bloody Skeleton
Copyright 2008 - Jason Koba

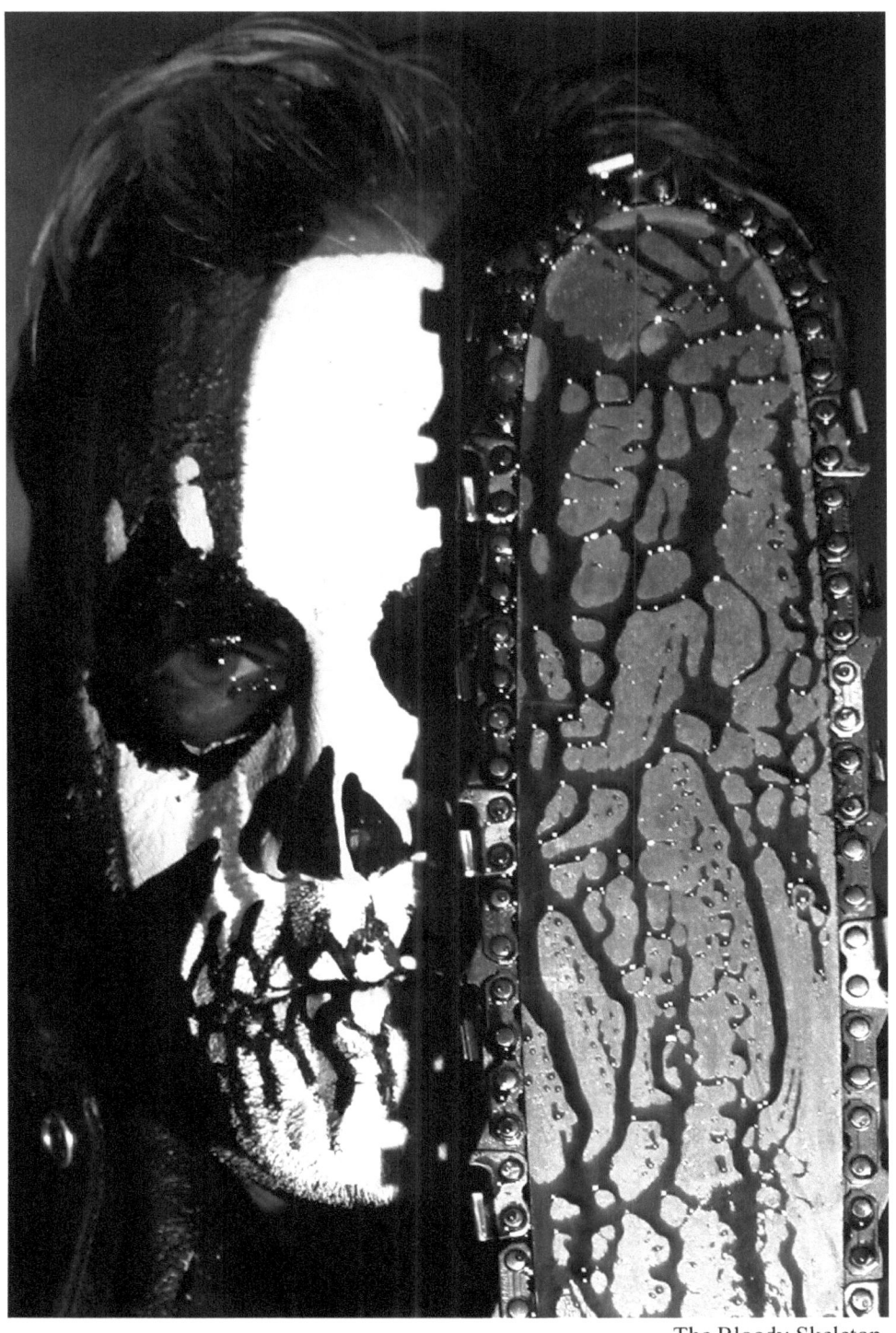

The Bloody Skeleton
Copyright 2008 - Jason Koba

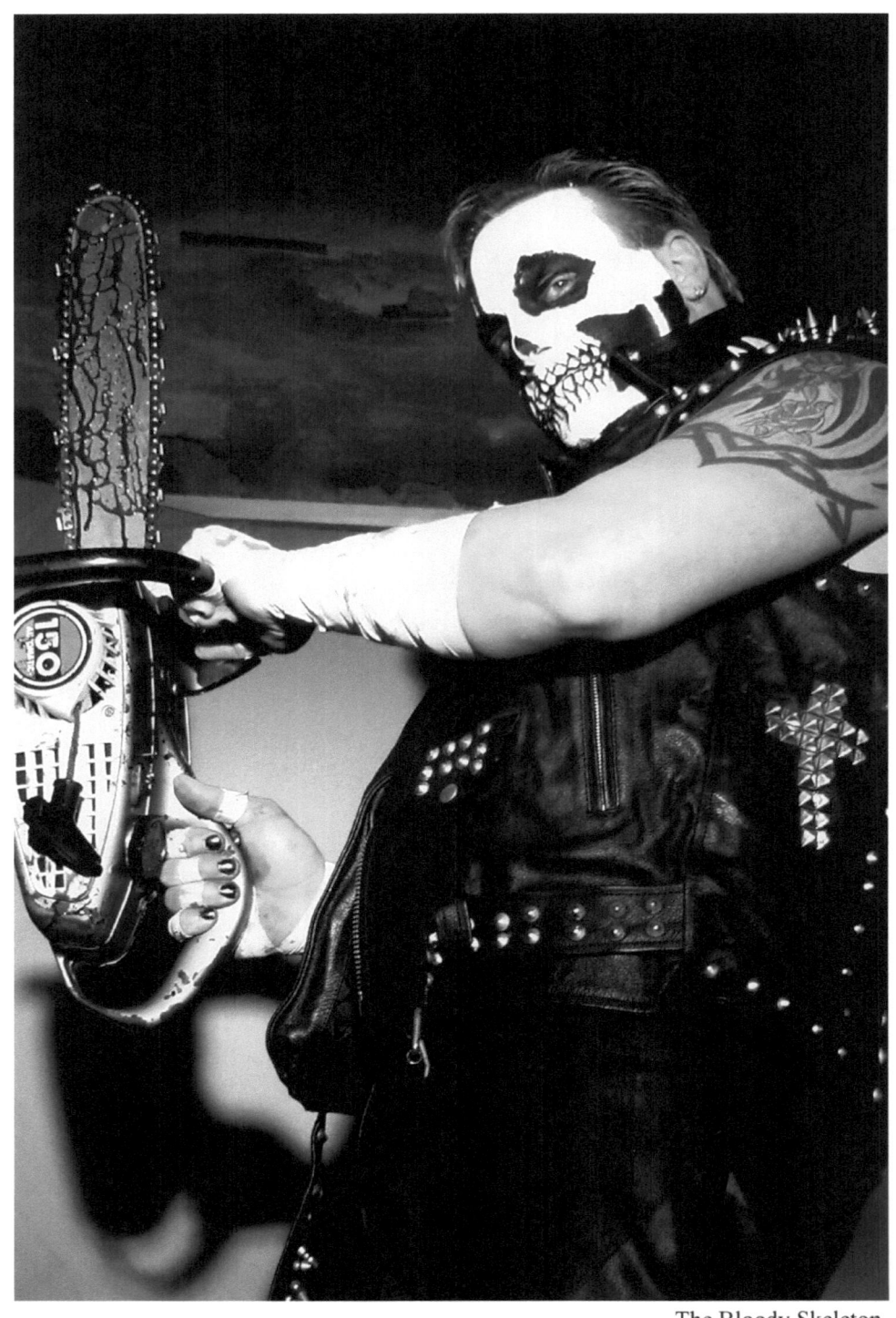

The Bloody Skeleton
Copyright 2008 - Jason Koba

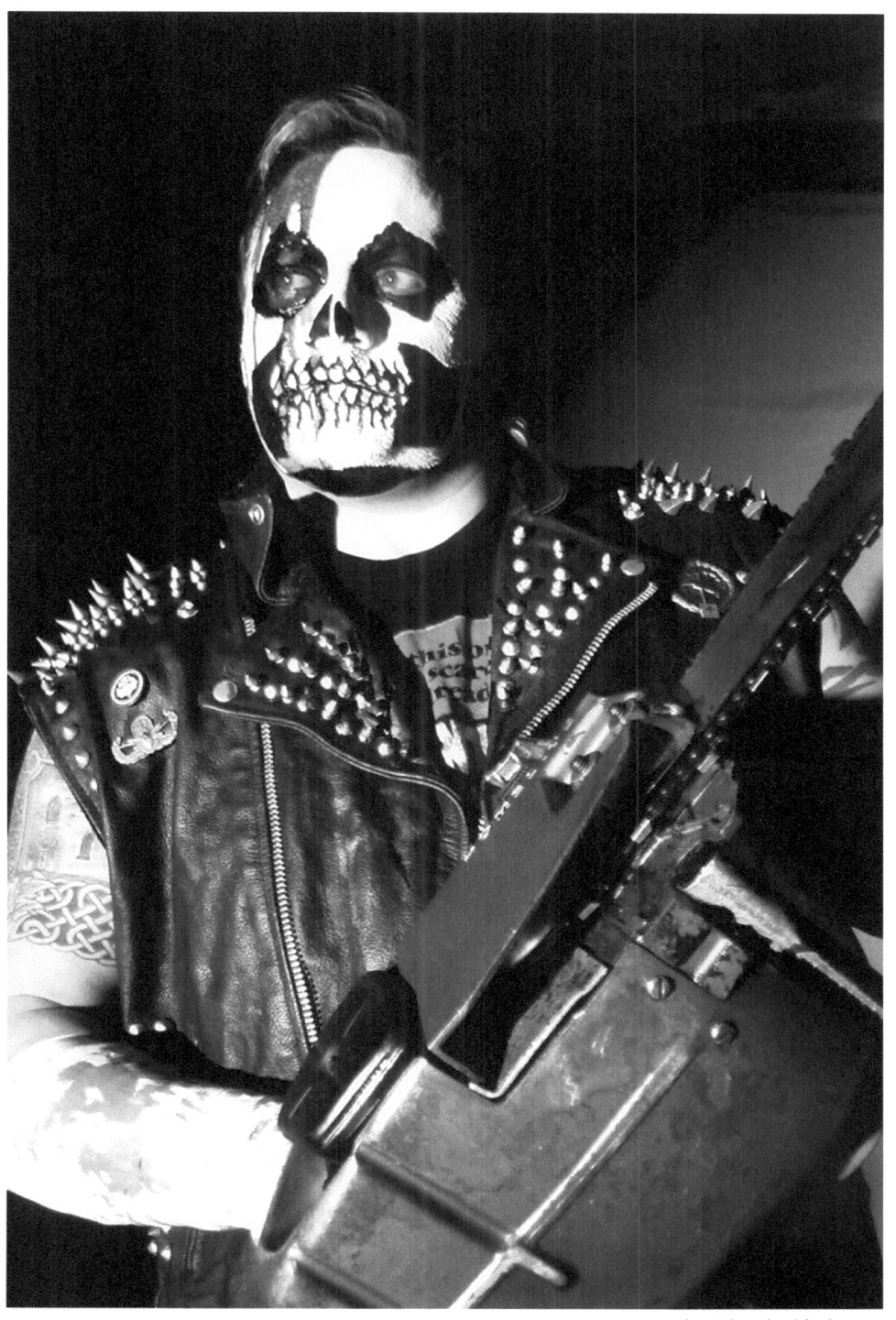

The Bloody Skeleton
Copyright 2008 - Jason Koba

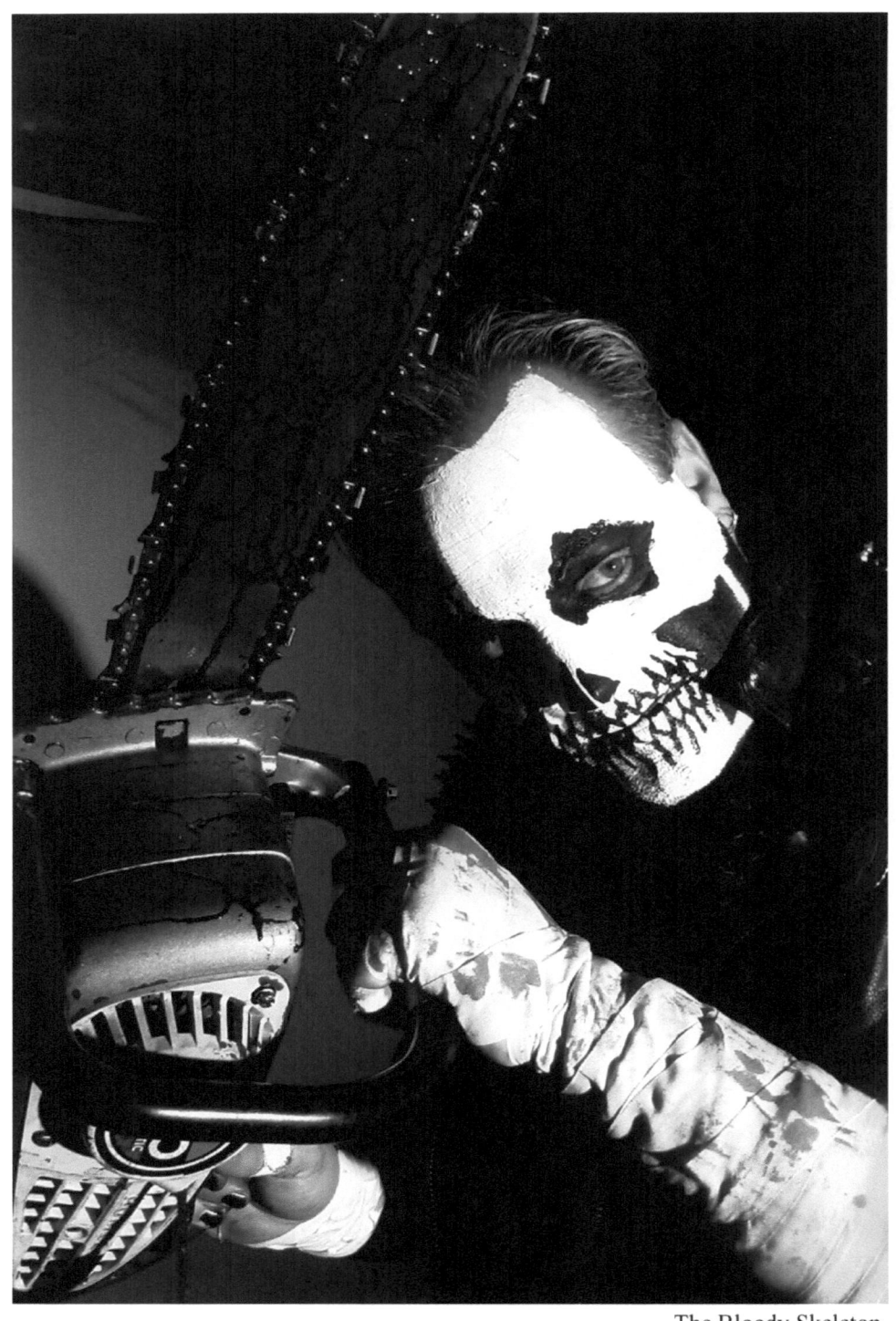

The Bloody Skeleton
Copyright 2008 - Jason Koba

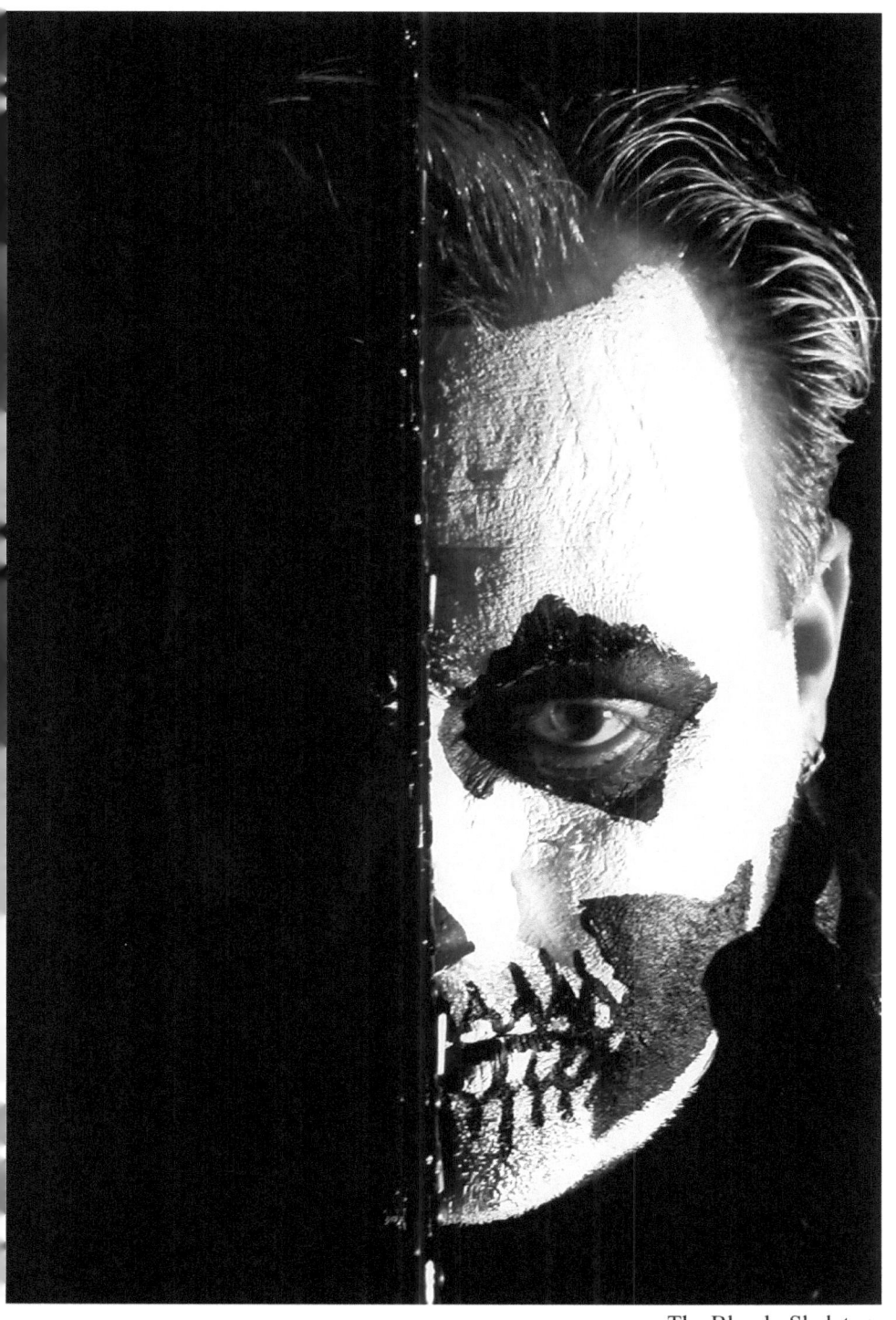

The Bloody Skeleton
Copyright 2008 - Jason Koba

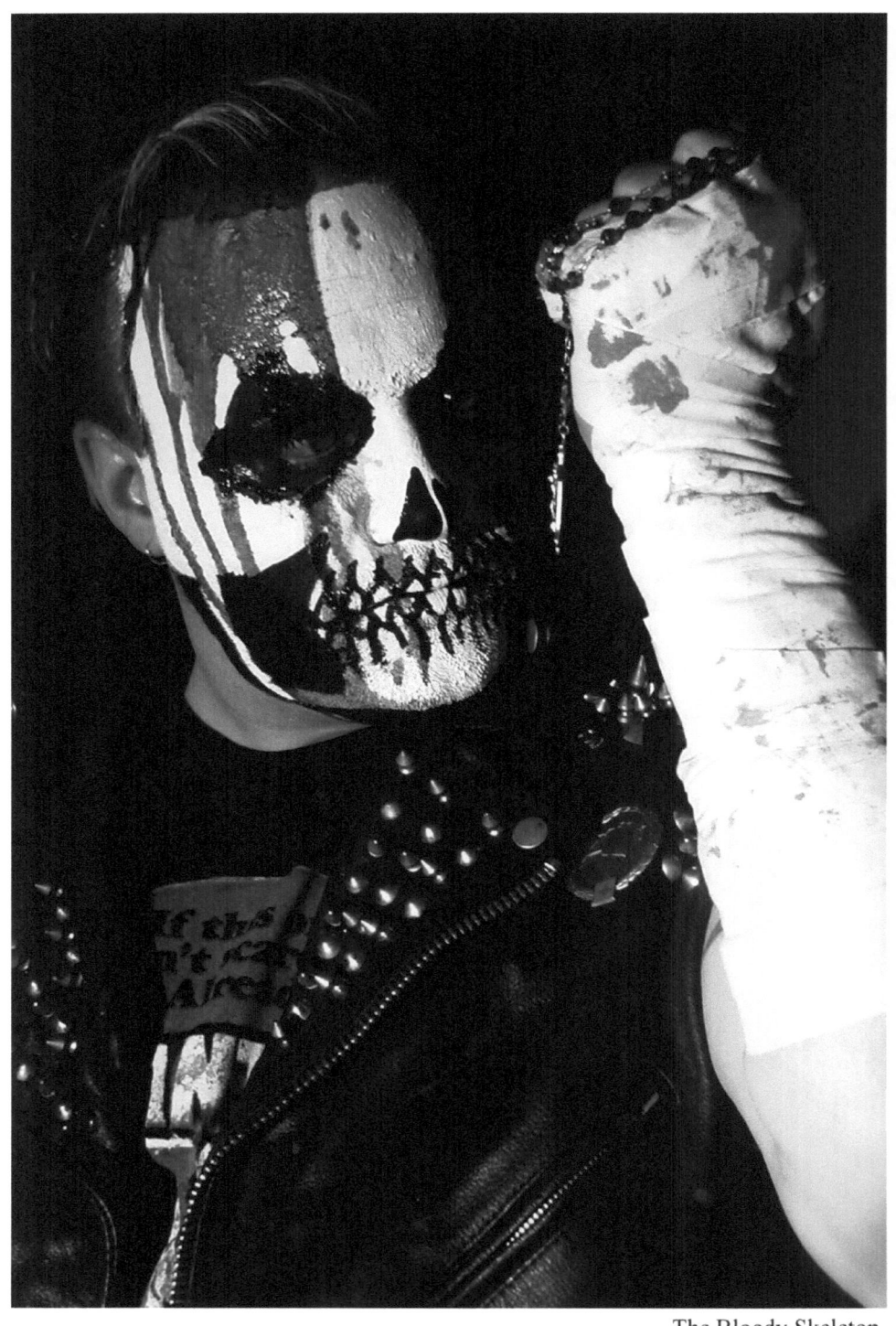

The Bloody Skeleton
Copyright 2008 - Jason Koba

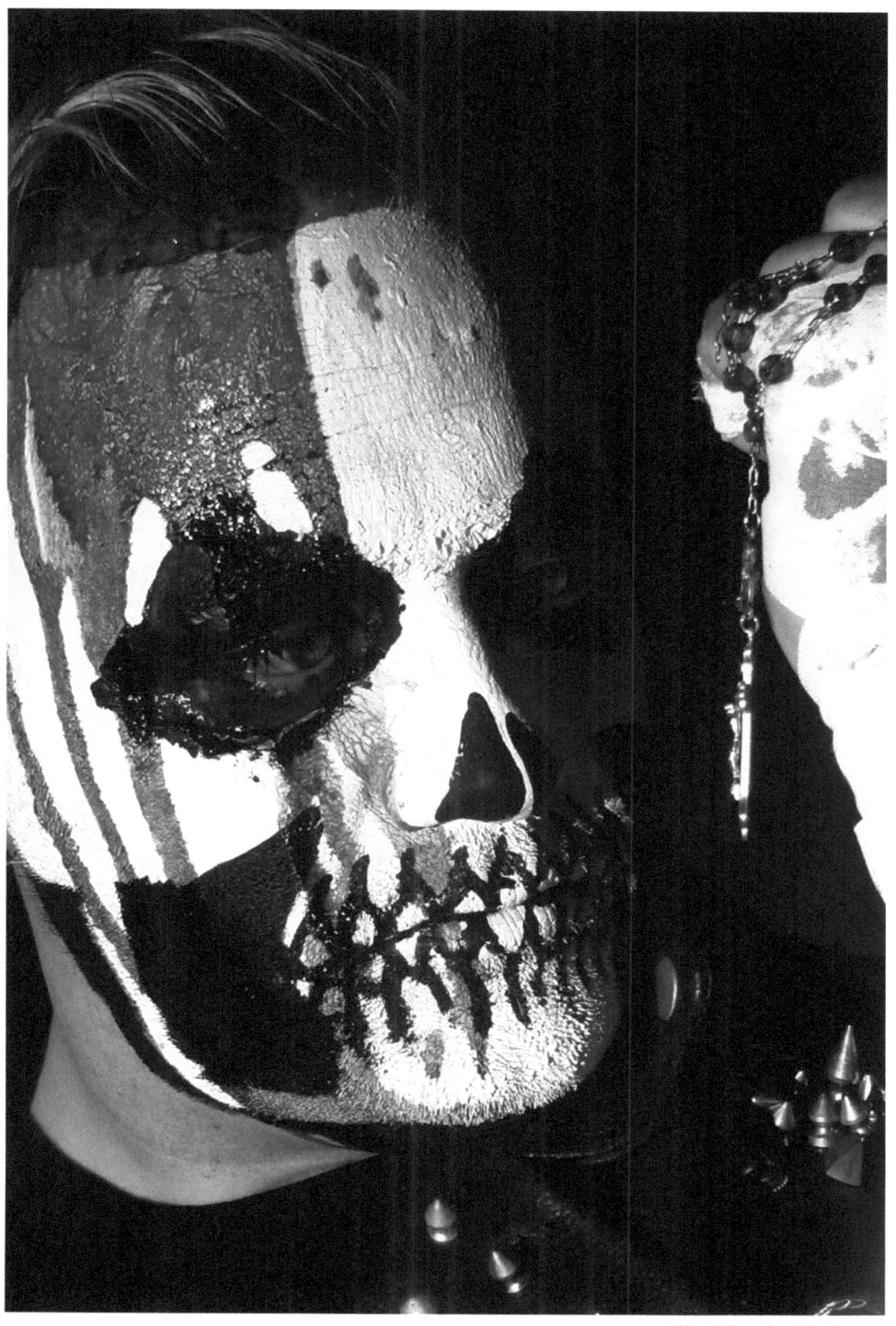

The Bloody Skeleton
Copyright 2008 - Jason Koba

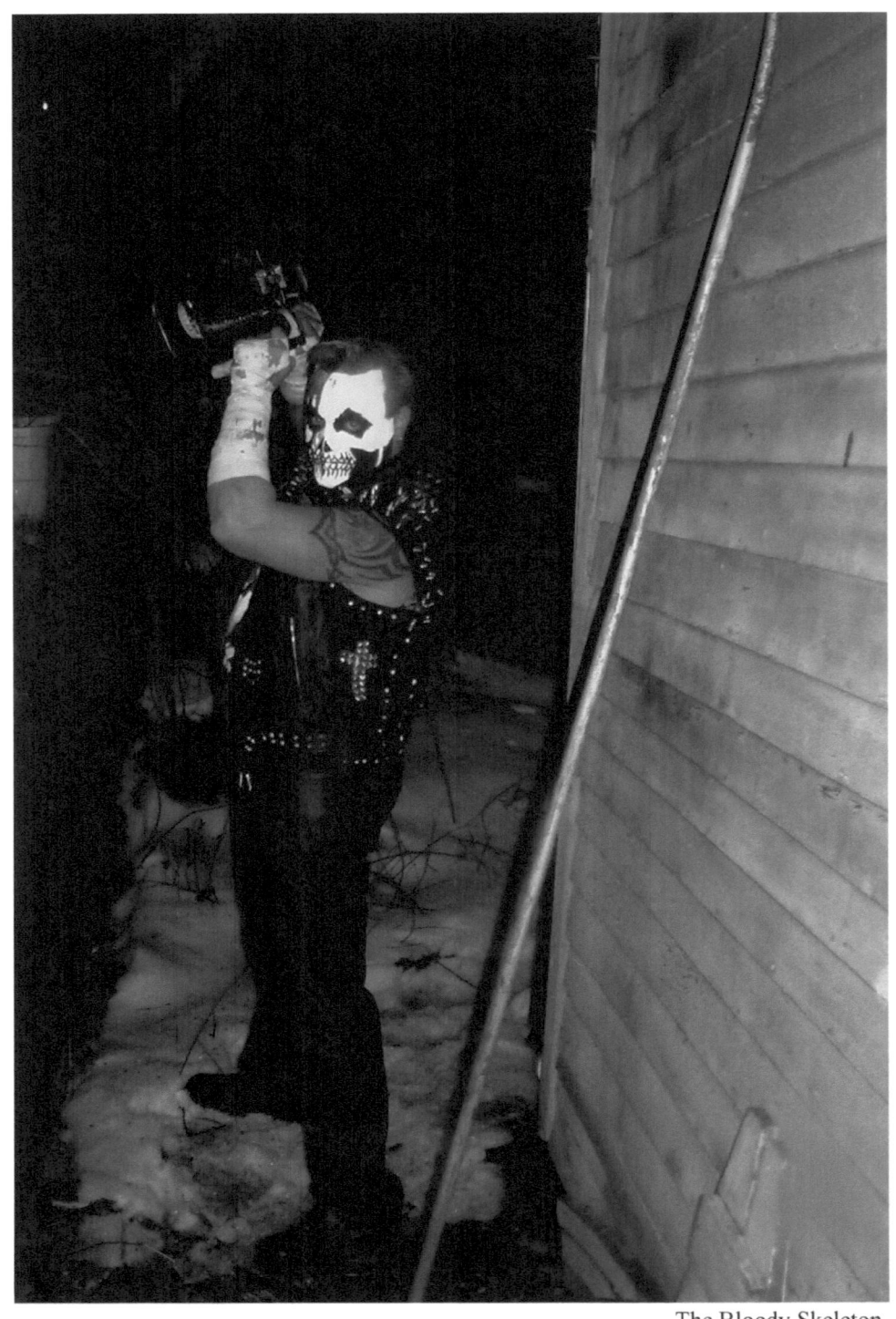

The Bloody Skeleton
Copyright 2008 - Jason Koba

PREACHER

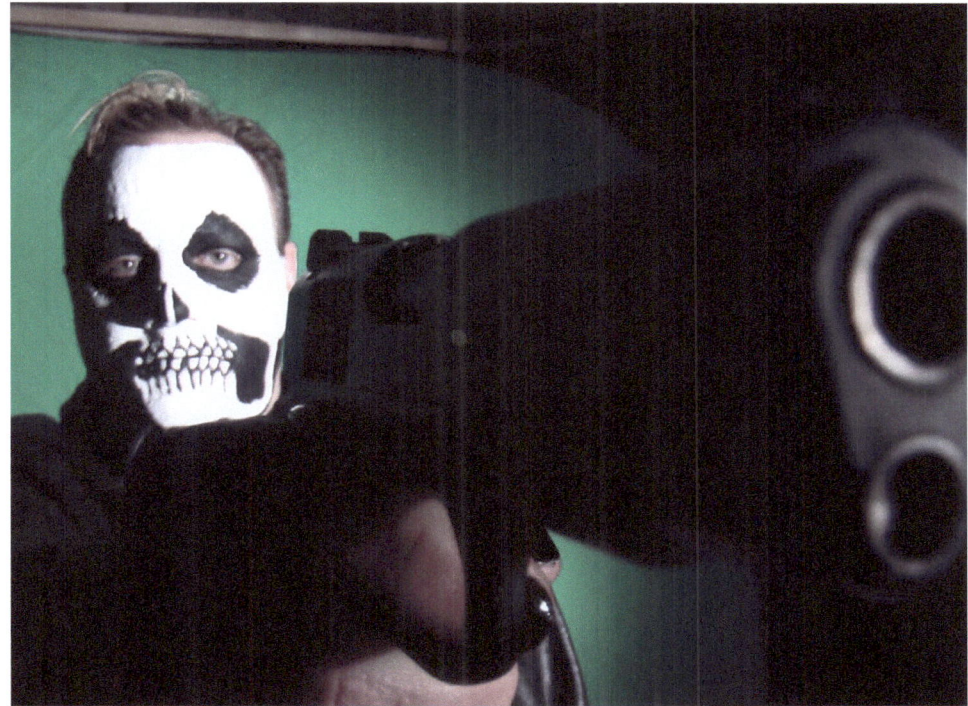

JOHN CANNON

January 17, 2009 brought in the New Year and another shoot with the "Bloody Skeleton" but this time he came as his other self. John is a lot of fun to work with because he puts a lot of effort into his characters. This time we had a visit from "The Preacher" John Cannon. Unlike his alter ego the preacher is more of a demon hunter with a dark past.

These pictures have never been previously released until this publication. I am proud because they show a distinct characteristic that I was unable to get from the bloody skeleton pictures.

Professor K

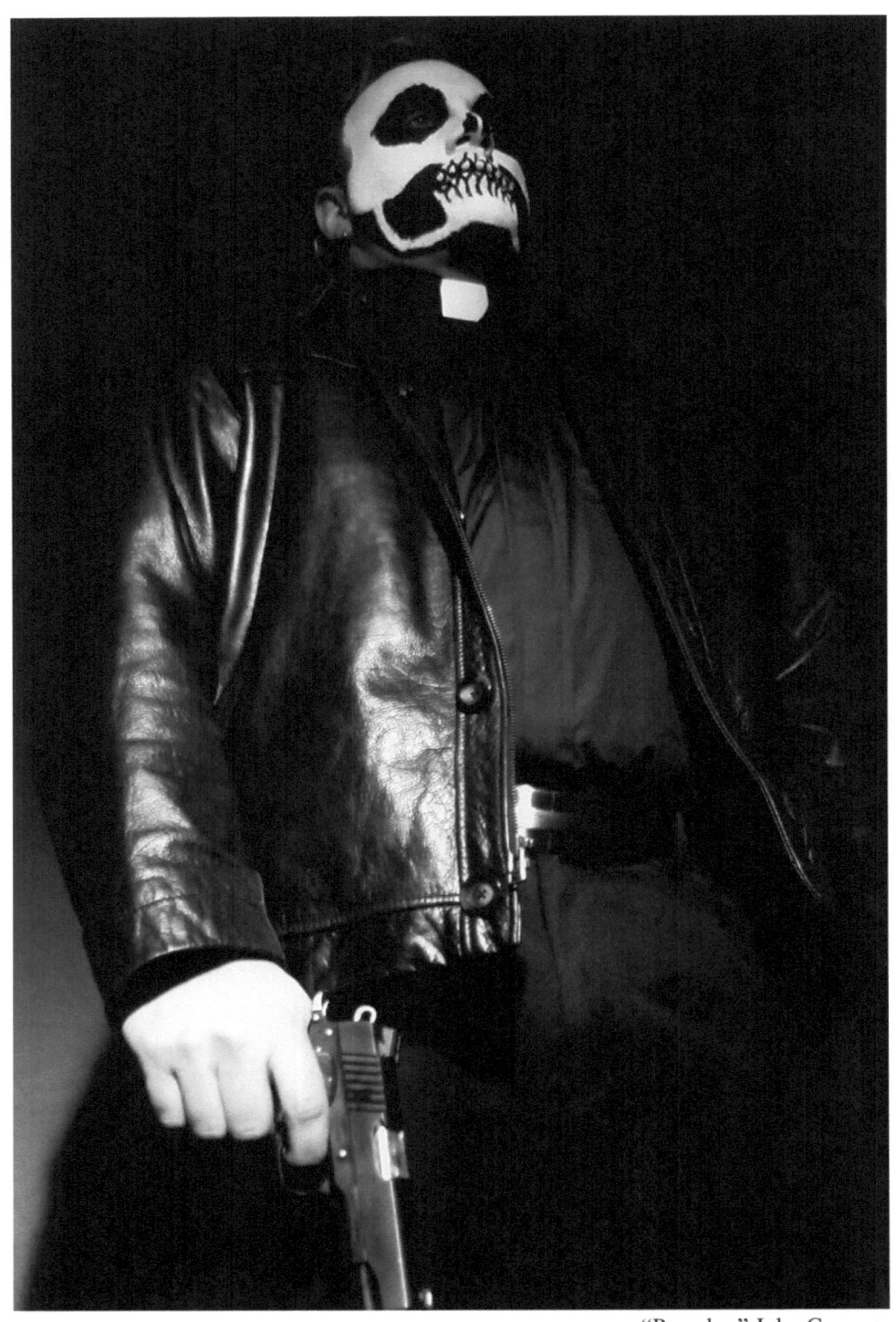

"Preacher" John Cannon
Copyright 2009 - Jason Koba

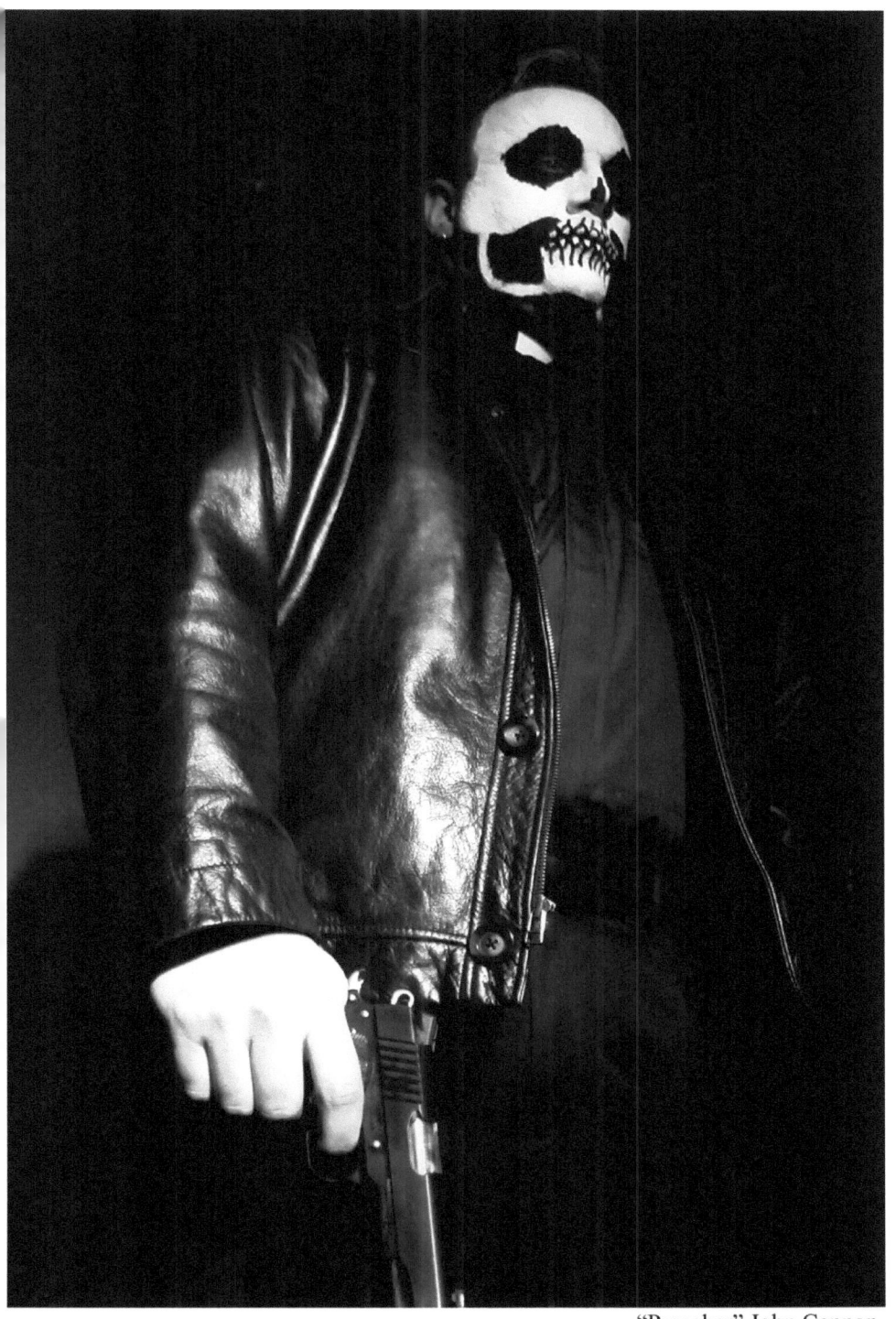

"Preacher" John Cannon
Copyright 2009 - Jason Koba

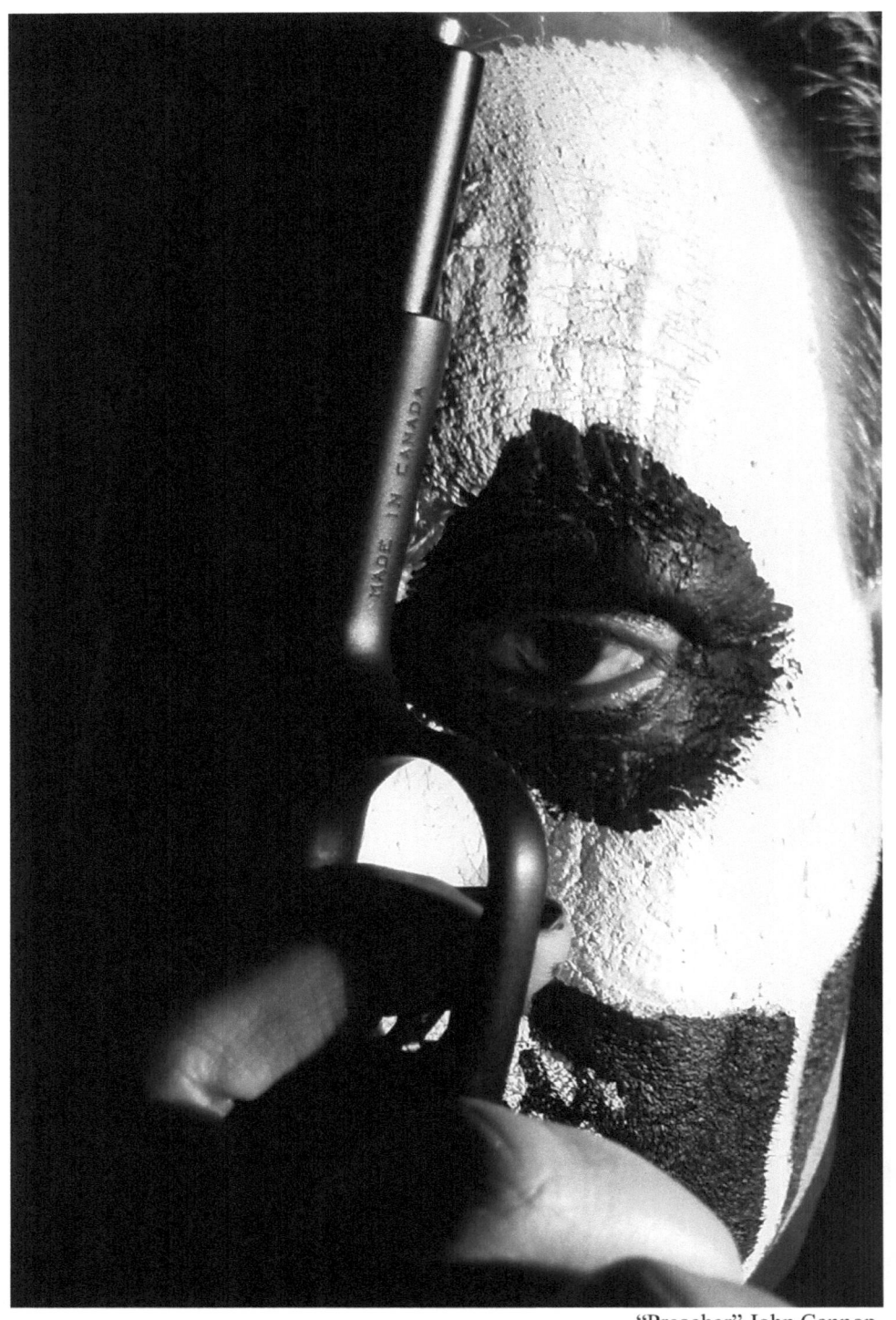

"Preacher" John Cannon
Copyright 2009 - Jason Koba

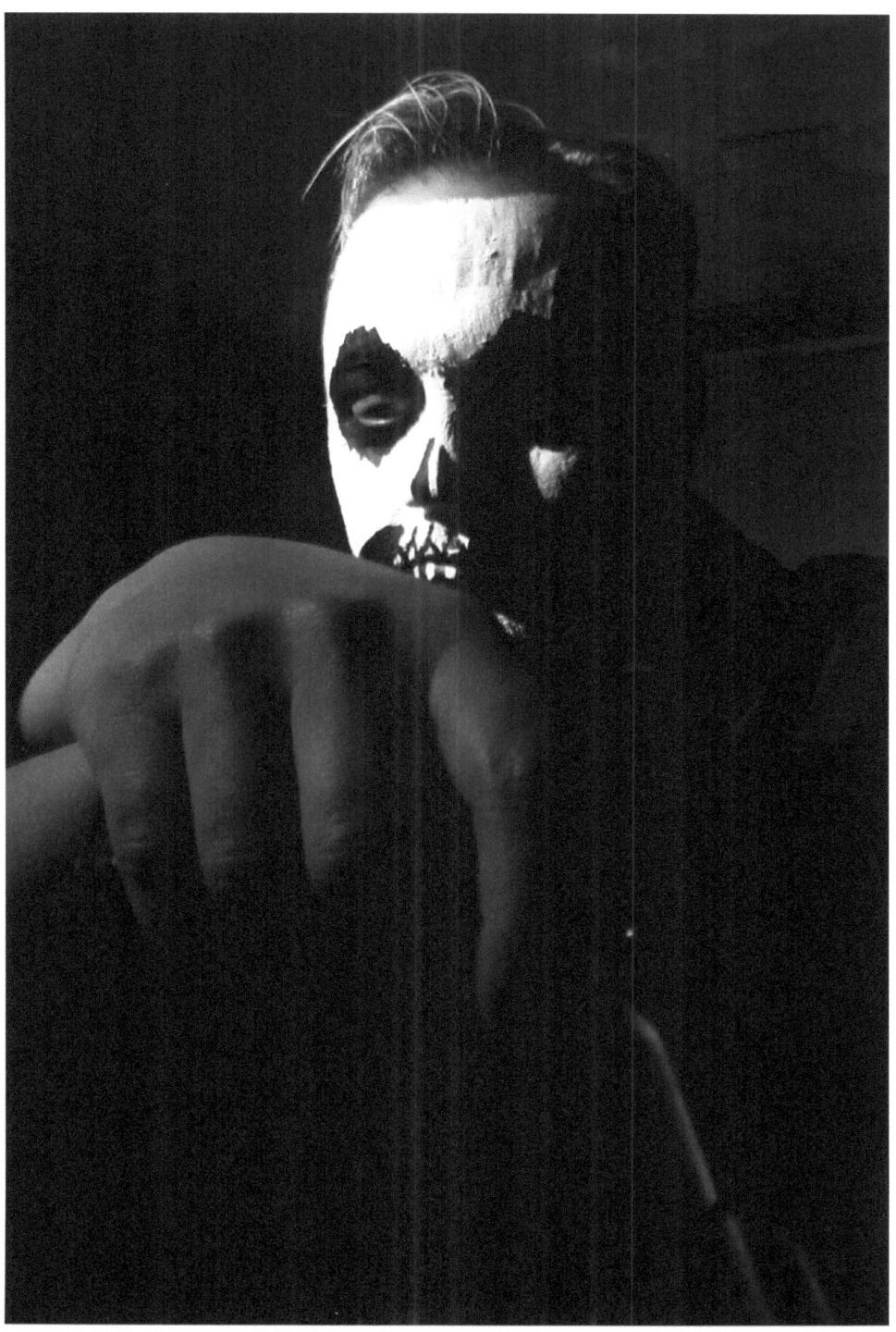

"Preacher" John Cannon
Copyright 2009 - Jason Koba

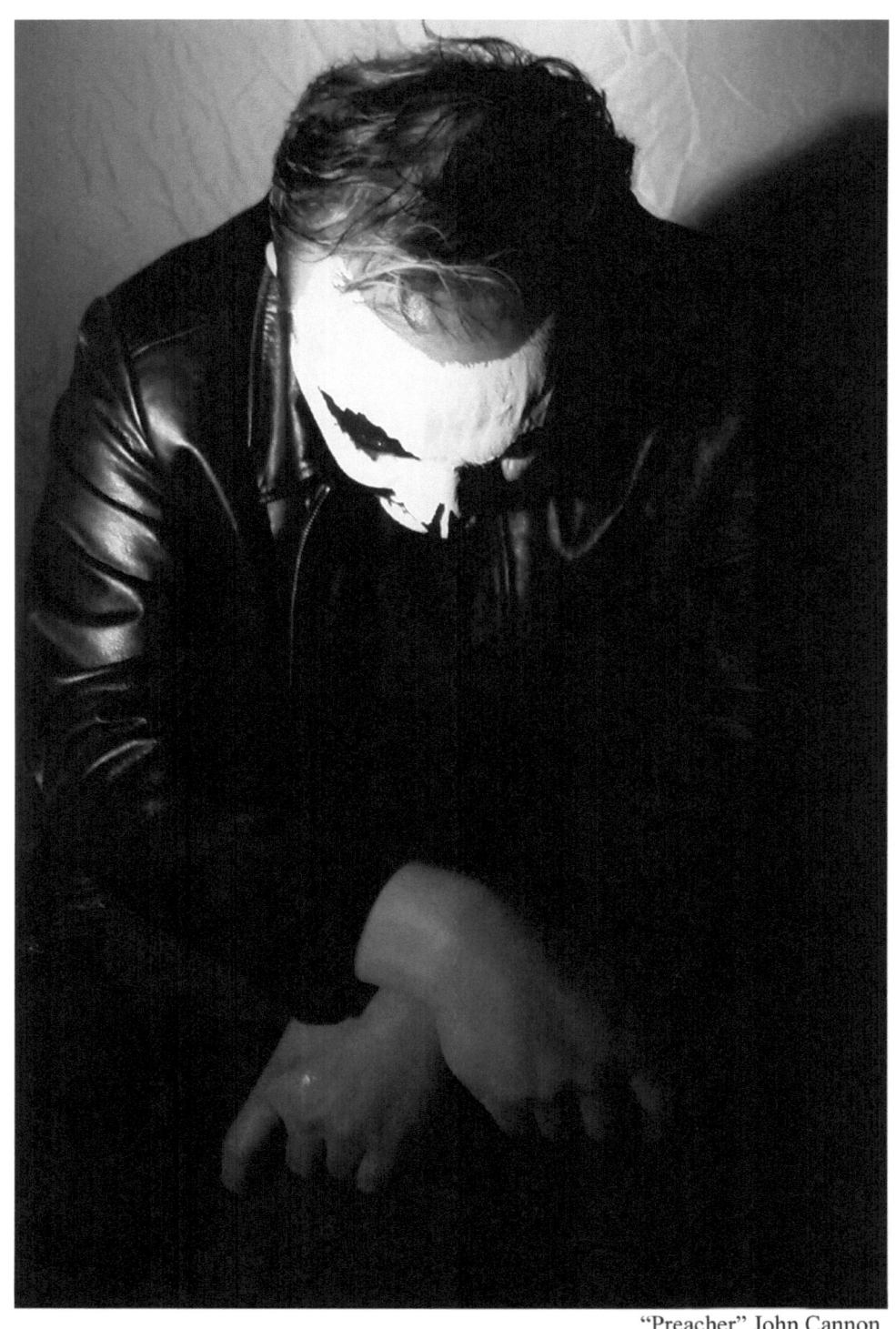

"Preacher" John Cannon
Copyright 2009 - Jason Koba

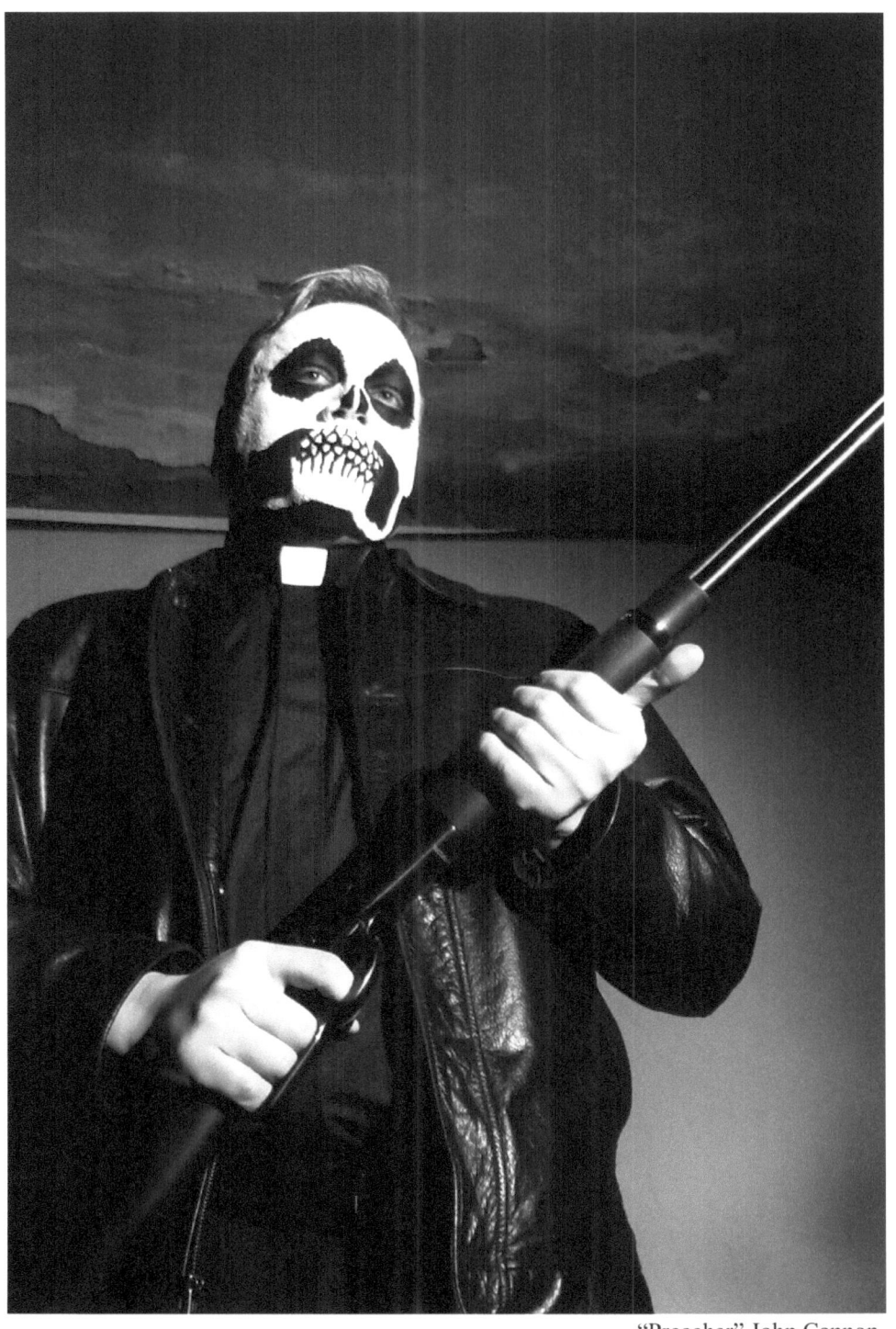

"Preacher" John Cannon
Copyright 2009 - Jason Koba

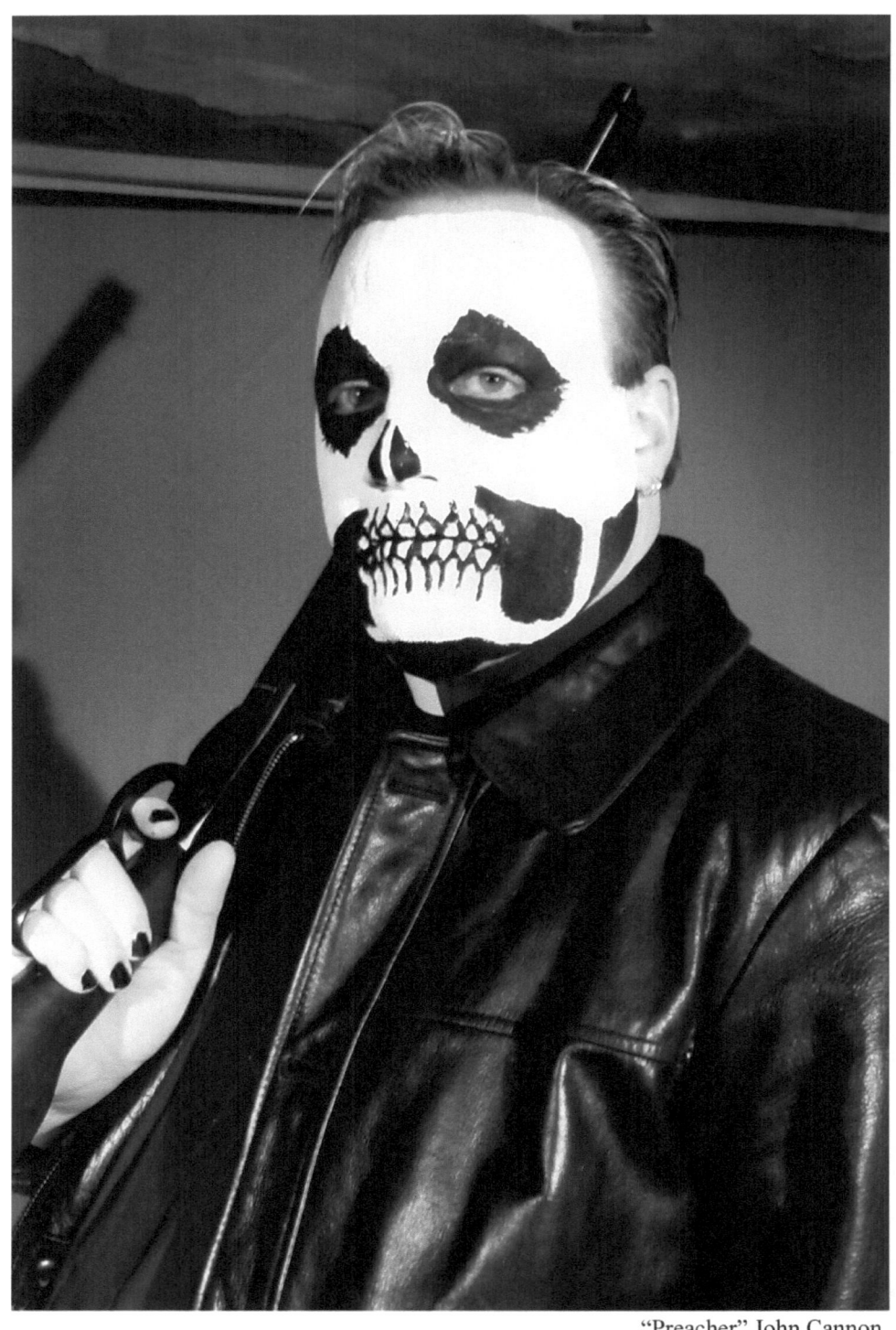

"Preacher" John Cannon
Copyright 2009 - Jason Koba

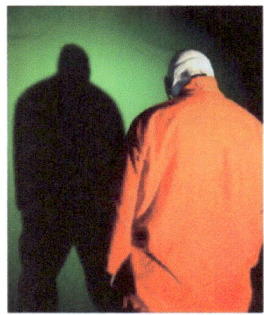
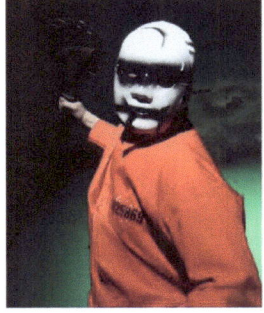
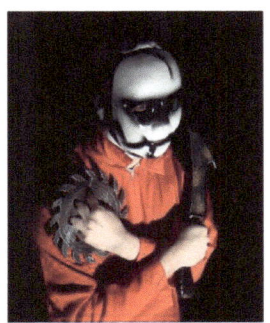
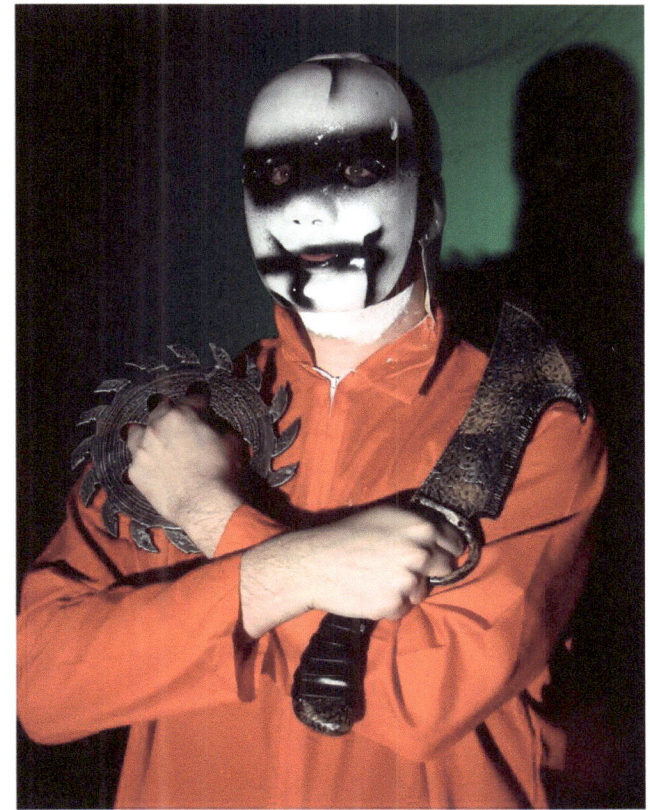

December 27, 2008 we started working on a new project called "Toxic Rage," which was a show of strengths between good and evil monsters with a hint of bad 50's horror films.

The project ultimately went on the back burner for awhile due to funding and advancement issues. In the end the characters created for this project came out well and the "Monster Akai" among others may come back for a project reboot some day.

Professor K

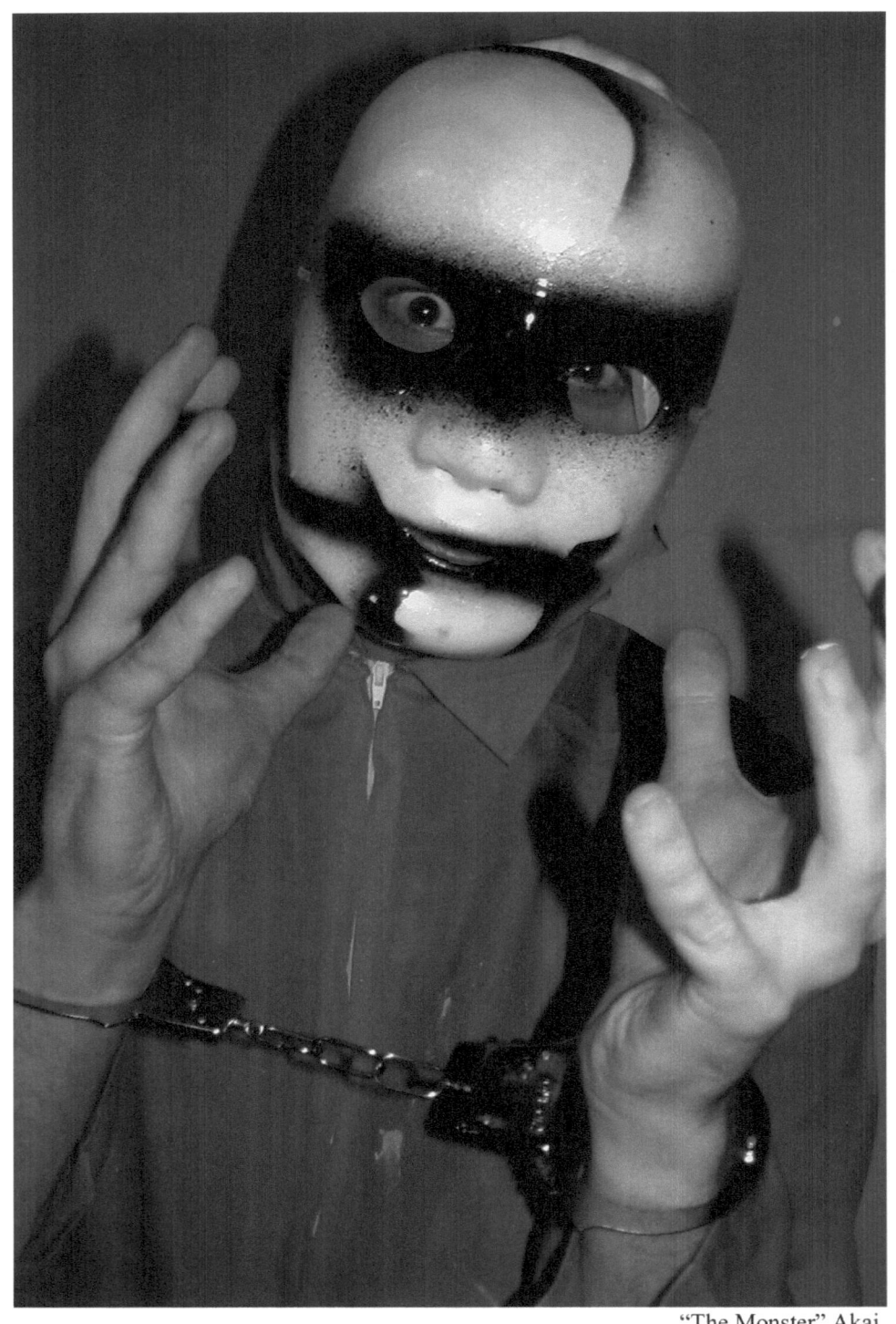

"The Monster" Akai
Copyright 2008 - Jason Koba

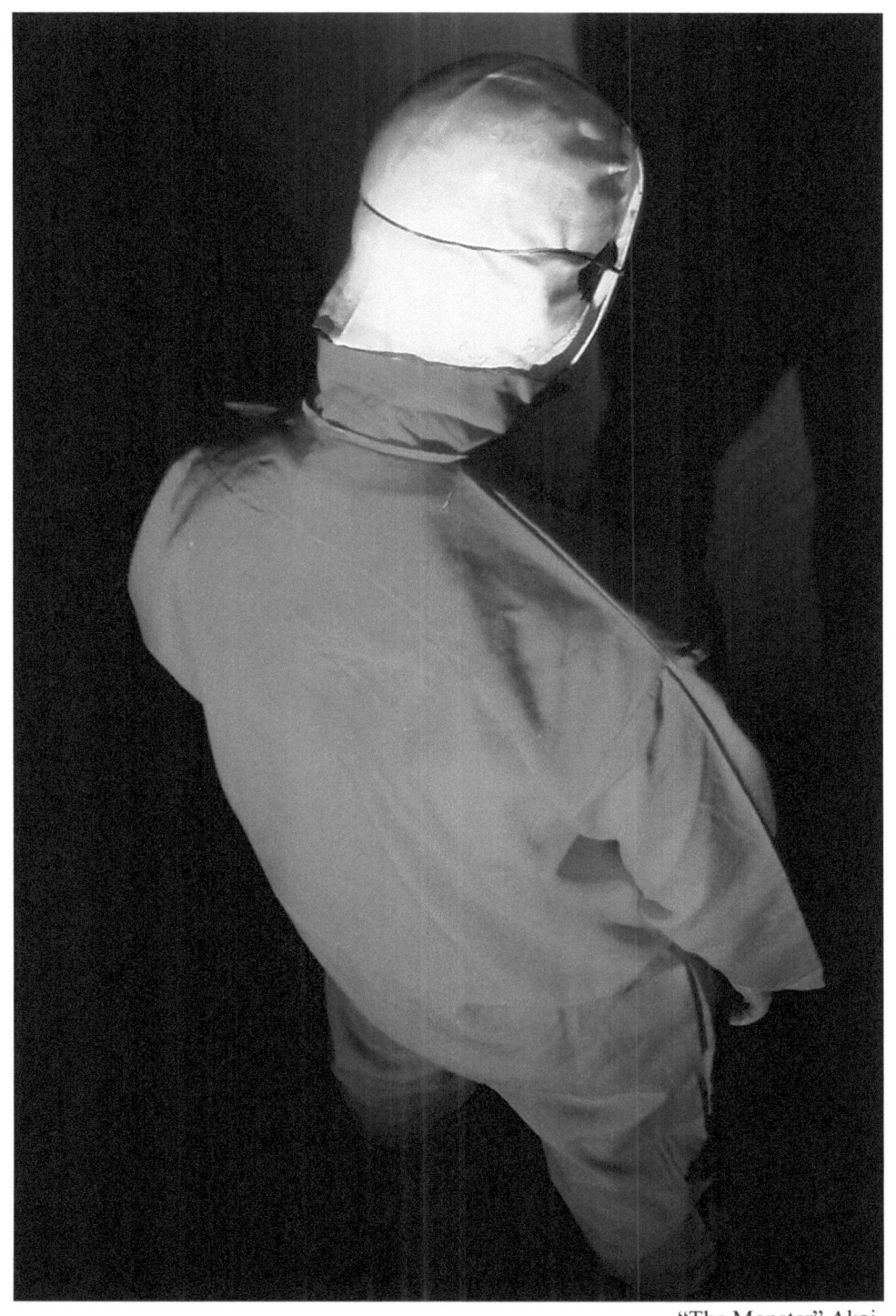

"The Monster" Akai
Copyright 2008 - Jason Koba

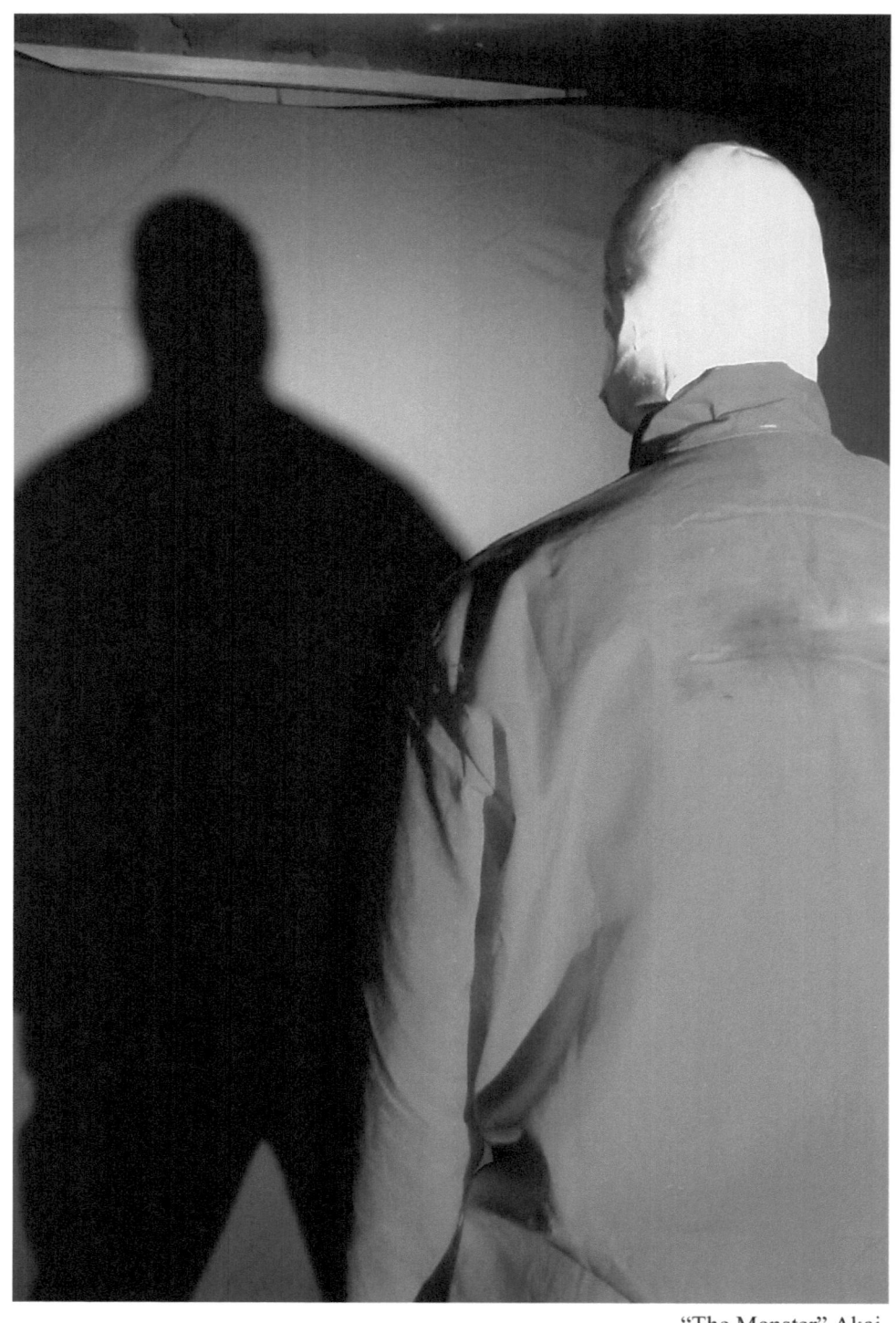

"The Monster" Akai
Copyright 2008 - Jason Koba

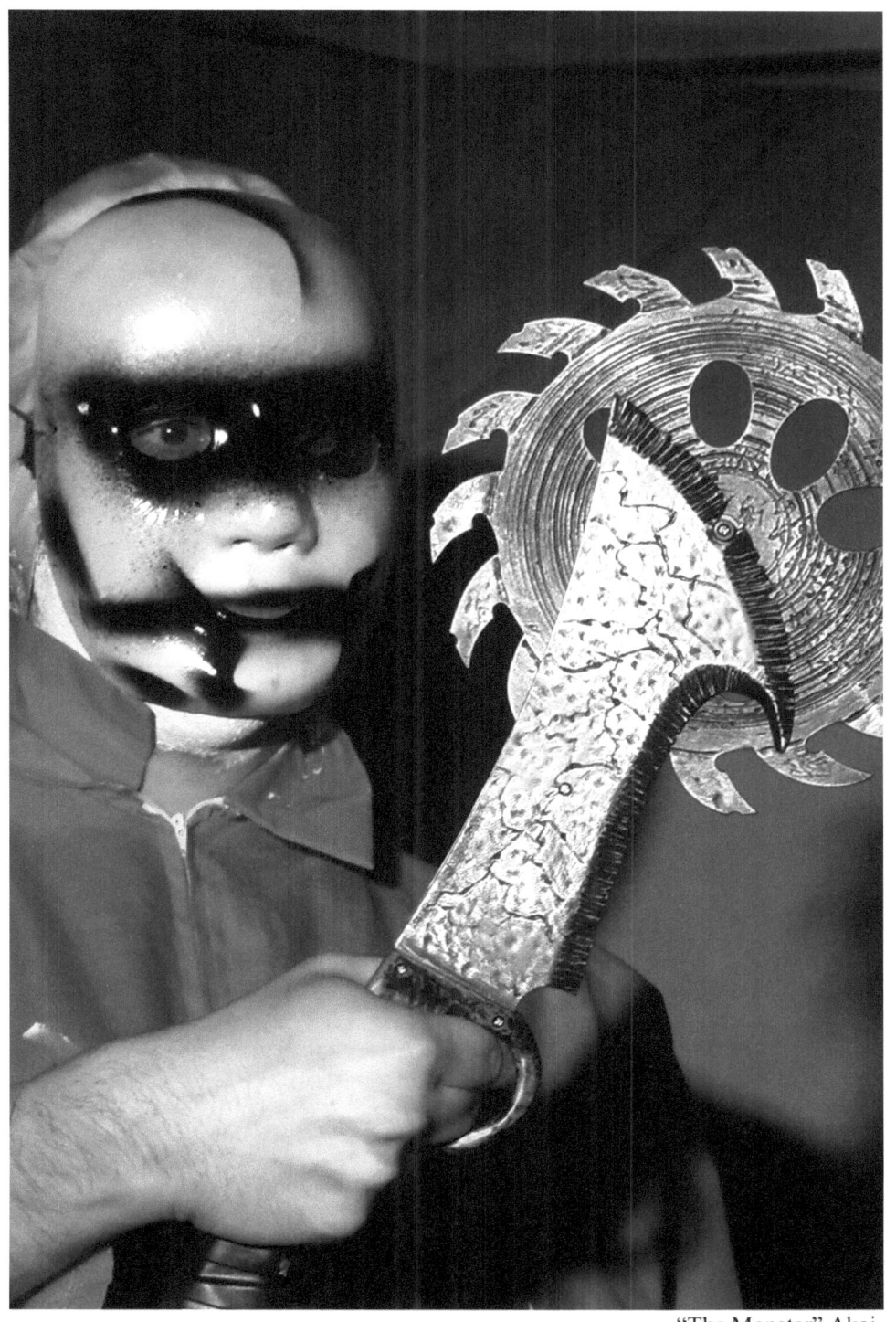

"The Monster" Akai
Copyright 2008 - Jason Koba

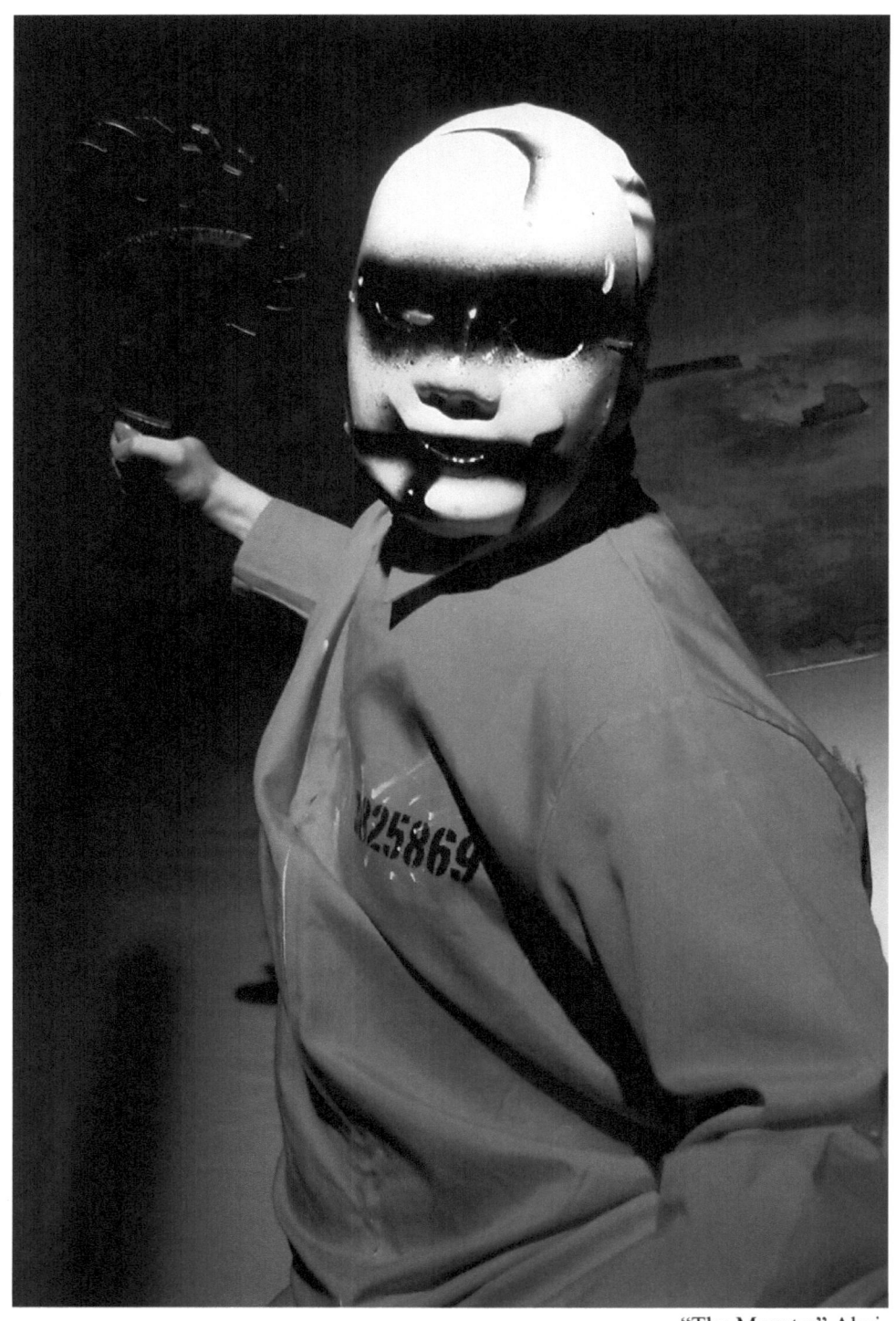

"The Monster" Akai
Copyright 2008 - Jason Koba

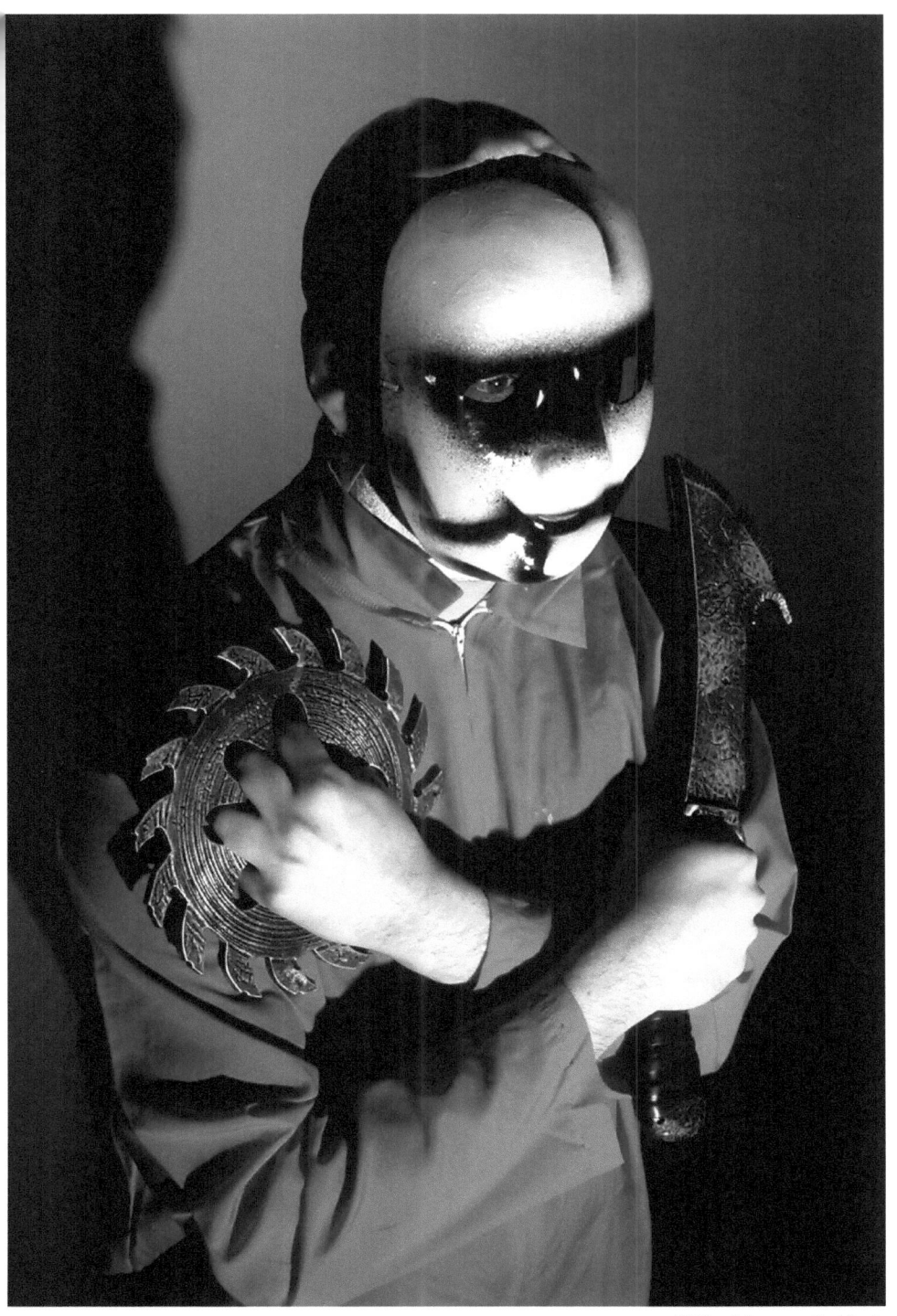

"The Monster" Akai
Copyright 2008 - Jason Koba

Also Available From Sound Impressions

The Eye Of The Beholder
The Photography of Jon Bolton

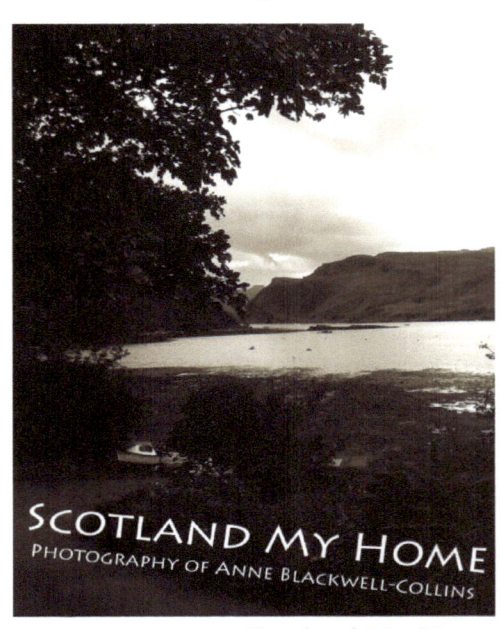

Scotland My Home
Photography of Anne Blackwell-Collins

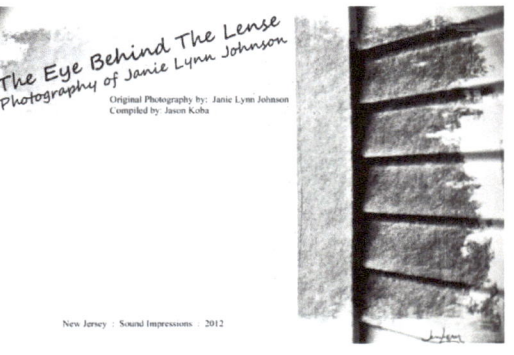

The Eye Behind The Lense
Photography of Janie Lynn Johnson

Available Now at
www.amazon.com and www.soundimp.net

www.ingramcontent.com/pod-product-compliance
Lightning Source LLC
Chambersburg PA
CBHW041612180526
45159CB00002BC/826